Rats Live On No Evil Star
by Allin KHG

2017 KHG InterServ
empallin@yahoo.com
Oklahoma City, OK

in my home town

they kill rats

they line them up

and shoot them one by one

they take them out

as soon as they get a good shot

they run them over in broad daylight

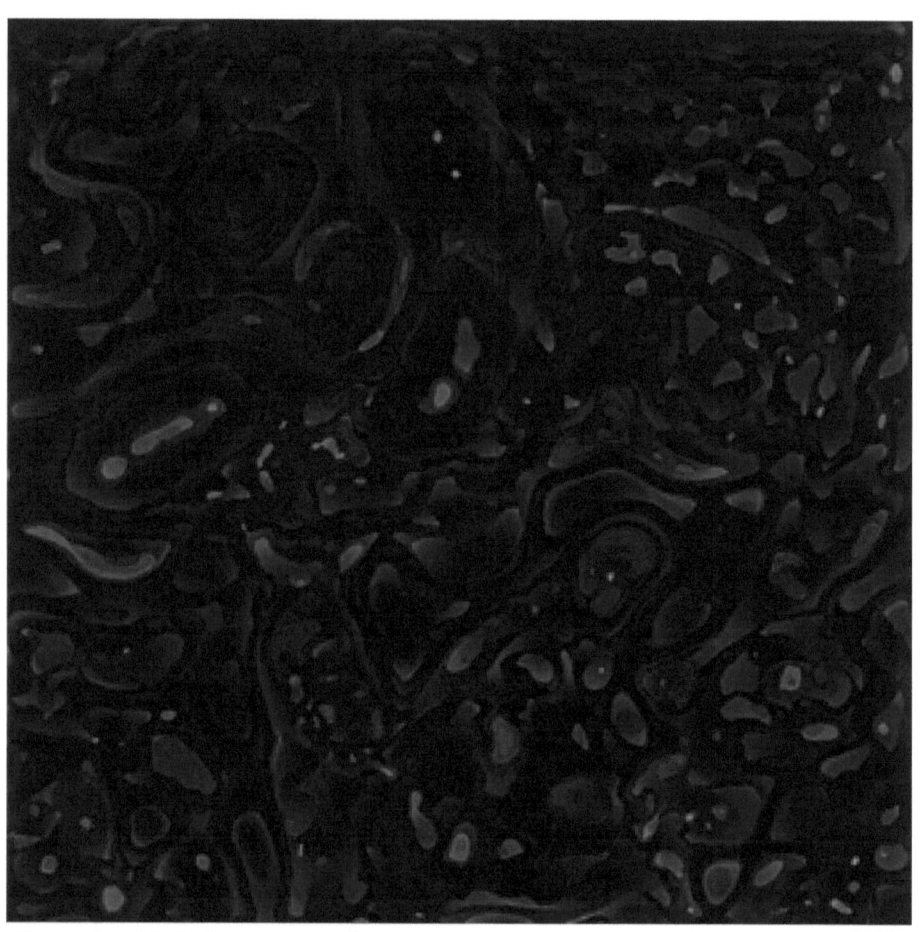
the rats think they are safe

around the monster

noisy filthy creatures

filling the streets and sidewalks

maybe they will be safer in the next town

they killed their king with joy

the rats will be of no concern

they kill rats as quick as they can

a quick and clean kill

run em over and call it good

rat eat rat

the bigger rats feasting on the weaker ones

a proud display of a lack of respect

now the star rats

sit high and mighty

on a rotten stinking

www.ingramcontent.com/pod-product-compliance
Lightning Source LLC
Chambersburg PA
CBHW041133200526
45172CB00018B/371